PRIMITIVE:
The Art and Life of Horace H. Pippin

BOA wishes to acknowledge the generosity of the following 40 for 40 Major Gift Donors

Lannan Foundation
Gouvernet Arts Fund
Angela Bonazinga & Catherine Lewis
Boo Poulin

PRIMITIVE:

THE ART AND LIFE OF HORACE H. PIPPIN

◧ ◧ ◧

Poems by

JANICE N. HARRINGTON

AMERICAN POETS CONTINUUM SERIES, NO. 159

BOA EDITIONS, LTD. ◧ ROCHESTER, NY ◧ 2016

First Edition
20 21 22 23 7 6 5 4 3 2

For information about permission to reuse any material from this book please contact The Permissions Company at www.permissionscompany.com or e-mail permdude@gmail.com.

Publications by BOA Editions, Ltd.—a not-for-profit corporation under section 501 (c) (3) of the United States Internal Revenue Code—are made possible with funds from a variety of sources, including public funds from the Literature Program of the National Endowment for the Arts; the New York State Council on the Arts, a state agency; and the County of Monroe, NY. Private funding sources include the Lannan Foundation for support of the Lannan Translations Selection Series; the Max and Marian Farash Charitable Foundation; the Mary S. Mulligan Charitable Trust; the Rochester Area Community Foundation; the Steeple-Jack Fund; the Ames-Amzalak Memorial Trust in memory of Henry Ames, Semon Amzalak, and Dan Amzalak; and contributions from many individuals nationwide. See Colophon on page 104 for special individual acknowledgments.

ART WORKS.
arts.gov

State of the Arts

NYSCA

Cover Design: Sandy Knight
Cover Art: *Self-Portrait, 1941* by Horace H. Pippin
Interior Design and Composition: Richard Foerster
Manufacturing: Bookmobile
BOA Logo: Mirko

Library of Congress Cataloging-in-Publication Data

Names: Harrington, Janice N., author.
Title: Primitive : the art and life of Horace H. Pippin : poems / by Janice
 N. Harrington.
Description: First edition. | Rochester, NY : BOA Editions, Ltd., 2016.
Identifiers: LCCN 2016006323 | ISBN 9781942683209 (softcover : acid-free
 paper) | ISBN 9781942683216 (ebook)
Classification: LCC PS3608.A7817 A6 2016 | DDC 811/.6—dc23
LC record available at http://lccn.loc.gov/2016006323

BOA Editions, Ltd.
250 North Goodman Street, Suite 306
Rochester, NY 14607
www.boaeditions.org
A. Poulin, Jr., Founder (1938–1996)

To my heart and my reader, RDP

CONTENTS

A TIMELINE FOR HORACE H. PIPPIN

1888 Born in West Chester, Pennsylvania, the child of domestic workers. His family moved to Goshen, New York, when Pippin was three years old.

1908 Pippin's mother dies.

1917 Enlists in Army and joins 15th Infantry Regiment of New York. In France, this regiment would become the 369th Colored Infantry Regiment of the 93rd Division of the United States Army, the legendary Harlem Hellfighters.

1918 Wounded by a German sniper's bullet.

1919 French government awards Pippin and the 369th Infantry the Croix de Guerre.

1920 Marries Jennie Ora Featherstone Wade Giles and moves to her home at 327 W. Gay Street, West Chester, Pennsylvania. Jennie Pippin works as a laundress. When Pippin cannot find work, he helps his wife by delivering laundry. Active in his community, Pippin will serve as commander of his African American Legion Post and help establish a Scout troop for African American boys.

1925 Makes his first pyrograph, a picture burned onto the surface of a wooden panel.

1928 Begins his first painting, *The End of the War: Starting Home*.

1930 Finishes *The End of the War: Starting Home*.

1937 Enters the Sixth Annual West Chester Art Exhibition.

1937 Holds his first one-man art exhibit at the West Chester Community Center.

1939 Robert Carlen becomes Pippin's art dealer and begins to promote his work.

1940 Alain Locke writes about Pippin's work in *The Negro in Art: A Pictorial Record of the Negro Artist and of the Negro Theme in Art*.

1942 Pippin finishes the John Brown Series.

1946 Jennie Ora Pippin is admitted to the Norristown State Mental Hospital. Later research by Selden Rodman indicates a possible amphetamine addiction.

1946 Horace Pippin dies July 6. Two weeks later, Jennie Pippin dies at Norristown.

I

NOW WHY DO I WANT TO GET UP SO HIGH

Died. Horace Pippin, 57, ex-porter, self-taught, a top U.S. Negro painter, whose works hang in nine major museums, many a private collection; of a stroke; in West Chester, Pa. Because a bullet wound paralyzed his right arm in World War I, Pippin had to paint his quaint, rugged primitives by supporting his right hand with his left, did it well enough to be compared favorably with famed primitive painters Douanier Rousseau and John Kane.

—*Time* 15 July, 1946

[T]he most important Negro painter to appear in America. . . . The facts that the work seemed crude in the sense that it lacked skill and finesse in the use of paint, and that it showed no evidence of borrowings from any old or modern artist, bore out the claim that Pippin had had neither academic training nor contact with the work of other painters. It was as primitive as the drawings of the prehistoric cave dwellers and it had the ruggedness, stark simplicity, vivid drama, naiveté, accentuated rhythms, and picturesqueness characteristic of the spirituals of the American Negro.

—Albert C. Barnes, 1940

Now why do I want to get up so high? Leave that to somebody else. If I don't go high, when I fall, if I do, I won't have far to go.

—Horace H. Pippin

PICTURE OF THE POET AND HORACE H. PIPPIN BEFORE THE PERIGEE

Under a sycamore's bough
a bat folds and unfolds.

The black iris opens, black,
purple-black, a thing of night.

I go out, when it is dark enough,
to see the perigee.

> Moon,
> milk moon, clabber moon,
> old woman's saucer.

I see my shadow on the sidewalk, the night shadow
of a night-colored woman, and remember his words:

We went to bed in the dark
and got out in the dark only the moon showing.

At Meuse-Argonne,
before fields of black mud, he looked at the stars.
In darkness always the same question,
how to sway darkness?

Beside the magnolia, I watch the perigee:
sap welling from a milkweed's stalk,
a Sunday pearl, an infant's skull.

I think of you
and your long-ago answer, to look,
and look beyond: small and necessary acts.

II

IF A MAN KNOWS NOTHING BUT HARD TIMES

He does much of his work at night or whenever he feels like working. It is simple in construction with color contrasts tastefully made. Art critics attempting to give a name to his particular type of painting, first called it primitive, and then something else, until they ran out of names.

—Joseph W. Woods

He cannot be said to have actually studied art, except for a year spent in observation at the Barnes Foundation where he mastered the usual four-year course in twelve months.

—Theodore Stanford

Is a black artist like Pippin caught in a dilemma in which he may be excluded because he is black (and therefore "inferior") or may be included because he is black (and therefore "primitive")?

This question gets at the heart of what it is to be a black artist in America.

—Cornel West

A PRIMITIVE PORTRAIT

Despite distortion—or because
of distortion—the eye lingers, stayed
by his white shirt, by the subject's demeanor,
by the clean attention and spare composition
suggested by—blue space? Blue air? Or maybe a blue wall?

Austere composition and attention in *Self-Portrait*, 1941,
where a man sits astride a slat-backed chair,
before canvas and easel. On his unseen shoulder
lies an unseen scar, the shrapnel of an unseen war.
In his lap, a cupped hand balances a brush in a cage of fingers.
His thighs, propped wide, are heavy and sexual.
"Art is dangerous," Ellington said.

"When it ceases to be dangerous
you don't want it." This is a portrait of an American Negro,
a Negro artist between the Scottsboro Boys
and the Detroit Riots, two years after the great contralto
and the very year that Kenny Clarke, Charlie Parker,
and Thelonious Monk would jam at Minton's.
He looks like the "New Negro," but with sleeves rolled and ready.

He triangulates body, chair, and easel,
a confident equation: I am, he says, I am,
as if any Negro alters the canvas. Skin
as canvas stretched taut over its frame.
What do we paint on it now? What did he?

Time shift. An MP3 player. Billie Holiday
speaks in a post-postmodern collage, a music shaped
from the reconstructed patterns of her voice.
I was scared to death. . . . I'm always scared. . . .
This is a portrait of a woman's voice, a woman speaking,

and the primitive music in any speech, the primitive
patterns that make speech, the music of speech, which
seems primitive. On another disc, Billie Holiday sings "Strange Fruit"
in 1939: *Blood on the leaves and blood at the root.*

A Negro "primitive" paints a self-portrait. But how?
What new freedom allows him to see, allows the art, allows
the man seeing himself as art, as artist, as he wants
to see himself, or wants you to see him?

Look again, at the portrait—heroic,
broad-shouldered, handsome, his piercing stare
(settling the question: He is a man, has a man's body,
a man's will, a man's sex, a man's gaze; it will not require
1,369 lightbulbs to see him)—at the hand that seems
too small, at the brush as long as his arm and tipped in white.
Notice his legs spread like a jazz drummer's. Though he never
improvised. He thought everything out. Foreground.
Background. His mind walked across the canvas.
His heart plied the paint like a gandy dancer.

I paint it. . . . I take my time and examine
every coat of paint carefully and to be sure that the exact
color which I have in mind is satisfactory to me.

There it is: satisfaction. To be satisfied
and black. To choose where and when. To determine the details.
Precisions that were not, as they said, primitive, but human.
On his canvas, he is in process, his brush tipped with *might be*
rather than *is so*, his lips latched by solemnity, words never
the medium for what he would seal with color.

The canvas tilts away from, refuses, our gaze,
the crude measure of our eyes. This is a portrait of a dark body,
a dark manhood, a dark center. The eye cannot avoid him,

cannot make him background or frame. He holds the brush,
already sees what he will paint, looks towards what will be,
what we do not yet know.

III

I'VE SEEN MEN DIE

At that time there were certain kinds of black men who I admired and they were the kind of black guys who I think came out of the first world war. They had self respect and he [Pippin] had lots of self respect. He knew he was strong. To me he was the kind of black man who wouldn't take too much smart alecky stuff from other people. Other people knew he wouldn't do that so they didn't try it with him.

—Edward Loper

Artist Gets Purple Heart 27 Years Late. West Chester, Pa. — (ANP) — Horace Pippin, artist, has been awarded the Purple Heart after waiting 27 years. Wounded in the Champaigne [sic] sector in France, Sept. 29, 1918, while serving in the infantry, Pippin was notified Tuesday that he has been awarded the Purple Heart by the War Department.

—*New York Amsterdam News*

LIKE THIS, LIKE THAT

For the 369th Infantry Division

Like this, like that
the men fell,
folded, flopped atop
the earth like fish.

Flounders floundered
in a sea of mud,
beneath gaseous nets,
black sky, choking sky.

They choke and cough
their grieving, suck *forget*
from a cigarette, and in a dugout's
wet they read their letters

and speak of girls
shapely as parlor lamps.
They pick their lice
and cuss, cuss, cuss the *Bosch,*

and in a quiet hush
they speak of home till
like this, like that
evening falls beneath the wire.

The sun, a mortar shell,
explodes blood gold, blood cold,
gilds the wire,
gilds the rat,

and shrouds their faces
in sanguine glory
before the night,
before the bayonet of night.

NIGHT MARCH, 369TH INFANTRY

> Even at night we could not travel
> without being seen by the skyline
> —Horace H. Pippin

Out of the gun-metaled dark, in the armored black,
come the muffled monologues of canteen and kit
and the knock of a rifle's stock against a weary thigh:
Harlem's sons marching in long onyx columns
over hill and ridge, hunched shadows shadowing
other hunched shadows. Under a bruised sky,
they hear the dirge of bursting shells and feel—beneath
hobnobbed boots, like the beat of an invalid's fist
against a board—the dull drum of battle. But weary,
they go on. Weary, they march, the Men of Bronze,

searching the darkness, spying in the galaxies above
a vaster army bright with bayonets, and in that starry
encampment the moon shines like a letter from home,
unfolded and full: *Come home safe. They're telling us
it won't be long now. Be careful. We miss you.*
Duty bound, they tuck away their memory of light
and march with heavy steps, with gear-bent
shoulders: the Soldiers of Democracy heading
toward a dugout's damp and the stolen sleep that
soldiers know: quick and deep and near to death.

A CANEL

Tallow, wick, flame, smoke, a *canel*
casts off illumination like shed
skin or estrus scent. A *canel*, a candle,
an incandescence—this need for light to see,

to read a shirt for lice, to read and reread
a letter already seared into memory, to seek
in a *canel's* flame proof that they are
what they used to be, brother, son, father.

Doughboy, you tried to light a *canel*,
to marshal fire in a dugout's damp.
But light is loss, we see and yet—there flares
the unseen, the shadow's veil, the corner

recast in cast-iron black. Such poor
technologies—*canels*, flamethrowers,
Very flares, the match the soldier strikes
for his last cigarette, or the char—

once human—caught on a barbed-wire rack.
Within a dugout's dark, a soldier tries
to light a *canel* and fails but then
earns its light and blots out all beyond

the boundary of its shining. He sees only
the splintered shelf where he will sleep.
He sees a gun's wooden stock. He sees
the animate mud that soils his cuff and seam,

but the men around him are only sonorous breath,
a creaking bunk, a cough, a blanket shifted.
Within a *canel's* light, the dimness merciful,
perhaps. He sees so little and only a little way ahead.

FINDING THE WORDS

This is the war, or
this is what he wrote, but meaning slips
like a *sirpen*, reptilian,
every syllable a molted sheath.

 Trees would snape of like a pipe stem.

 The shells would be piled up like a cord of wood.

 The water ran down my rifel like it would ron
 down a leder of a house.

He tried to find words, but
war is *like*. War is *seems*
and *as if*, a hard language.
Apt his broken syntax. Apt his errant spelling.

 It were in picess and you could not
 make them out. There were two men in it
 and they looked like mush.

 I could heare them shells birsteing
 back of me they would sound like thounder.

Soldiers, black men, lowly things,
belly-walkers, creepers—*We would stick to the shell hole*
like a sirpen—serpents without hands
to stall their movement onward, without
fingers to petition, tighten into fists, or count
the buddies gone, lost, left to rot.

I could not do any theing, he said.

Word *sirpens:* their constricting
friction in the throat, their cruel venom.

SHRAPNEL

Serrated / steel,
ballistic / trajectories,

death //
as small as / a splinter.

Pieces /
too small / to cull,
cut free, or count.

Half / men // half / metal,
perfect twentieth-century / machines.

THE SPELLER

Writing with your rigid shoulder, with the weaker
hand, two years after the Great War, you try
to shape words that you could not spell, sounding
them out—*raineing, playen, bob wir, infinze*—rolling

them on your tongue like Demosthenes' stones,
leaden shot spat out at shying targets. In a notebook
you bend the language:

hell place, nomansland—and mark in ink
uncertain places—*Leeon, Oregon, Caintenerzair,*
Moperycort. But words are poor gazetteers,
compasses for the lost. We stumble

over consonants and vowels. We are strangers
in our own language. What to call the ripped earth
where boys wait in ditches beneath bursting shells?
You called it *teribell grond of sarro*, spelled
so that we hear the voices ringing with terror,
the howl of the o, and the deeper o of sorrow.

FORMS AND SHAPES

From the notebooks of Horace H. Pippin

he looked like he was scared through, then again
he looked like every nerve was shaking.

I never saw a man like that before. . . .
His eyes all but bulged out of his head,

he said I am not coming back. I told him
he didn't have to go. But he said no

I am going through with it but I am not coming back.
And the boy didn't come back.

(A German had run him through.)

I have seen men die
in all forms and shapes, but never one who knew.

The next morning, I woke
up and dead men were on
both sides of me

that afternoon we got in a cross fire
of machine gun that took away

about all my platoon.

that afternoon we got in a cross fire
of machine gun that took away about all

It only left four un hurt.

men were laying all over the field and road
men that I knew also my buddy.

I looked to see if I could do him any good I could not
for he were done for.

found the body of men
that were on the line at that time

then two shots a guard
broke by
the still shot
morning he were
air and down
he went he went
down air and
he were morning
shot the still
by broke
a guard then two shots

cold

cold and some

cold and some of the boys

cold and some of the boys died

cold and some of the boys died there

cold and some of the boys died there of sickness

cold and some of the boys died there of sickness of the influenza.

I am going through with it but I am not coming back.
And the boy didn't come back.

(A German had run him through.)

I have seen men die
in all forms and shapes, but never one who knew.

I am going through with it but I am not coming back.

FIRE

In his knapsack, he tucked a notebook of sketches
limned in hurried slashes and pencil strokes:
the 369th Infantry, France during the spring
and summer of the war, lovely names—
St.-Nazaire, Bois d'Hauzy, Maffrécourt,
and unlovely—Champagne-Marne, Aisne-Marne,
Meuse-Argonne. Battles and blasts delicately
drawn, delicately shaded by the colored sketches
of a Negro doughboy, leaves of witness that—
for security's sake—he burned. Nothing whispered:

*Don't. They will want to know. Your memory
will be trophy and ossuary and record.* Nothing
stayed his hand or shouted: *Stop!*

A Negro soldier burns the pages of his notebook
beside the door of a dugout, undisturbed. The pages,
like paper fists, open and curl to grasp each flame's
finger. The blackened leaves rise as smoke rises.

And in the trenches, black men pass around
the last smoke before the wire, the stub passed
from mouth to mouth, sweet with spit, sweet
because it is the last, drawing the smoke deep
into their lungs, letting it rise, knowing they must follow.

HARD

No work as hard, hoisting

slack bodies, wrestling

the dead through wastes of mud

over a ruptured earth.

> *We were tryeing*
> *to get back with oir dead ones*
> *it were the hirdes job ever I had,*
> *to grag a dead man*
> *over that roff nomanland.*
> —Horace H. Pippin

Heaved, dragged, lugged,

the sacred work of war not to bury,

not to weigh with stone or ceremony,

but a more arduous labor, *hirdes,*

—to lift, to carry, always.

HORACE PIPPIN'S RED

Look. . . . It's not so heavy now. But it's passionless. Perhaps no red can have that passion unless a body has been painted near it or inside it. Could it be that red is the colour that is continually asking for a body?
—John Berger, *I Send You This Cadmium Red . . .*

1

Not So Heavy Now

The dead man lay on top of him, heavy
as mud, unmovable, leaking blood.
Blood of two men mixing like wines,
blood mixing with mud, mixing
with rain, the icy gray rain that tasted
like blood, like sweat, like the words
men cry out unheard before they die.

He could not move the weight, push
death aside, not with a blasted arm, not
while blood seeped from his splintered
shoulder. Thirsty, cold, waiting—
the sniper where? His unit where?
The corpse held him and would not
let go Death's intimacy or the last
gift the dying give: to hold us,

to linger. Death heavy as . . . an hour
abandoned in a maw of mud. What to say
to a dead Frenchman, the soldier
who tried to save you? From his bullet hole,
small black vowels leak *mon dieu,*
mon dieu. But what to answer?
Why does he hold you? A man

dead because Death would not
allow a man to reach for another,
to save him, to lift him. Death's
cynicism: there can be no heroes.

2

Unless a Body Has Been Painted

with sunlight, skin, the beloved's lick
and salt-slick sweetness, with rain

spilling, with shadow, soap, salve,
with tattoos of scent, unless a body has

been painted, touched, smoothed
with grease, slashed with elm switches,
pushed, shoved, straddled, unless a body

has been painted, swaddled,
scarred, worn mud, blessed with blood,
is it a body? Is it a human body?

3

Red Is the Color That Asks for a Body

How does the eye read color? Are you sure
about the hue of your skin? Does the light
deceive—inconstant light that never stays?

Deceived, we think we are dust, but we are
articulations of light. We are flames.
Our tongues are brands. They burn

and incinerate words. To paint wounds,
dip a boar-bristled brush or tip a finger
into cadmium selenide or cadmium sulfide.

When the Hebrews painted red on their lintels, death
passed over. Red is the color that asks
for a body, even this body you failed to save.

IV

WAR BROUGHT OUT ALL THE ART IN ME

The war had been a shattering experience to Horace Pippin. He would not have admitted it. He may not have "known" it. But the drawings, and to a far greater degree the war paintings that were to follow in twelve years, cannot be denied. He had seen the desolation of earth, the ruin of cities, the inhumanity of man.
—Selden Rodman

I made some seens of france, somtheing like a hundred of them yet at last I hatto Birn them up, But I can never for get suffering, and I will never for get sun set. that is when you could see it, so I came home with all of it in my mind. and I Paint from it to Day. I no notheing this is my—feature art—it came the hard way with me.
—Horace H. Pippin

TELL MY HEART

> Pictures come to my mind; I think my pictures out with
> my brain and then I tell my heart to go ahead.
> —Horace H. Pippin

His reds always clamored—mortars bursting, a plane afire,
a gunner's barrage, gladioli, gunshots, or Golgotha's
blood rain. He made no distinctions. His roses were fists.

His roses beat obdurate fists against the eye. The stunned
eye faltered, unable to distinguish: lonely—lovely,
both flames, both red, both proof of wounding. With a heated
poker, he seared winter into the grain of a table leaf.

Lonely was a winter storm, lovely was the heated poker.
With one hand cradled in the other, his left hand levered
the right. The right hand ferried the poker, held the brush.

The brush raised its slurry of reds, its cadmium pyres
and zealot's blood. It stuttered against the canvas, plied
its impasto of lonely—no lovely—and lay the pictures
that swayed his wary heart: Go ahead, now. Go ahead.

Go ahead. Watch closely: A wounded vet, Negro doughboy,
coddles a hog-bristle brush dipped in leftover house paint,
limns, in scalded red, a fox running beneath a pelt of sky.

Beneath a pelt of darkness, loneliness snaps its jaw, breaks
bone and useless wing, and wrenches the neck that swings
the unheard tolling of its bell. The thief flees, leaving
only a squander of blood to scald the wasting snow.

LOSING THE WAY, 1930

Oil on burnt-wood by Horace H. Pippin

21 lynchings
The *New York Times*
 capitalizes Negro
Marian Anderson sings at
 Carnegie Hall
Dunham's Ballet Nègre

What cripples—the wound or the scar? The *can't* or the *can't no more*? At his kitchen table, a man once scorched a story into a table leaf with a heated poker, the story of a man trudging with horse and wagon through a bleak and weary snow. The story started with a line. The tip of the poker slid forward. Vision—when you're ready to burn and be burned in return.

Huddie Ledbetter arrested
 for murder
As I Lay Dying
Civilization and Its Discontents
Ellington's "Dreamy Blues"

A man travels before a dark wood. *Nel mezzo del cammin di nostra vita mi ritrovai per una selva oscura ché la diritta via era smarrita.* Lost, he makes his own path with a broken body, with time, with violence (the poker). In your own winters, how far will you travel to find the road?

Gwendolyn Brooks
 publishes her first poem
Lorraine Hansberry born
Julius Rosenwald syphilis
 studies in Tuskegee
Paul Robeson as Othello
 at the Savoy

A portrait of a man with snow and loneliness—too far away to see his face, to see if he is you, to see if he sees you. Loneliness is snow and sleet and ice. In his notebooks, Pippin described his first winter in France. So cold, he said, he didn't know what to do. On cots in canvas tents, boys dying from influenza, a drowning death, lungs turned into melted snow. *Teribell grond of sarro,* he wrote, meaning their dead bodies, meaning the snow.

Zora Neale Hurston
 and Langston Hughes
 write *Mule Bone*
Gandhi's Salt March

What does a man carry when he's lost? If he sets aside all that he carries, will he travel faster? Cold hands, cold feet, the breath of the animal beside him, the muffled turn of wagon wheels. Just a little further, he thinks, a little ways ahead. I'll get there.

PROPHET

I knew him. I knew him. He was a big cornfield darky,
filled with the religion that Negroes get and he used to
quote Isaiah there in his studio, or any other of the great
prophets, little or big; he was filled with it.
 —Elizabeth Sparhawk-Jones

He was filled not, as they thought, with certainty,
—but with faith—which in the way that a blade
of bluestem is not a blade of switchgrass,
is always particular, he was filled with *his* faith.
Filled: to contain fully: to have no capacity
for more, desire sated—though when is desire sated?

And so his reaching—he was filled? No, not filled.
The mind is never filled and never empty. Faith
cannot satisfy. Unfilled, he reread Isaiah 11:9,
painted the prophet's revelations: the cow eating
placidly beside the wolf, the black child sitting
on the same lawn as the white, white crosses
and red poppies above the graves of soldiers.
He asked, studied, prayed, practiced the obsessions
of the self-taught: a gift for pattern, a faith in repetition.

They shall not hurt nor destroy in all my holy mountain:
for the earth shall be full of the knowledge of the Lord—full,
that is what he said to them. Artist, soldier, *cornfield darky*,
this was his prophecy. That sated, we would
have no faith in victory or defeat and there would be no war.
Sated, our avarice could end. And so his canvas and so
he turned old wounds into paint, and so the color red—
to kindle satisfaction, to make the eye for one brief moment
believe, and require in an instant—nothing more.

SURFACE, DECORATION

Steam above a kettle's spout,
a broken rung, a Bible's red tongue,
a Victory vase, sunlight on an oak leaf,
a domino's pip, the stem of a clay pipe,
the hemorrhage of a wounded Christ.
The way a doily resembles
barbed wire, and barbed wire a necklace
of thorns, of black birds,
black beaks threaded on a black cord,
commas and parentheticals—
the propositions of a self-taught eye:
the sublimity of the everyday. In *Harmonizing*
Pippin paints knots in a pine fence—
each knot a mouth. Everything speaks.
Everything sings I am, I am.

Nothing apart, nothing beyond, nothing without its texture: polka dots, stripes,
florals, a weave of bricks. The artist painted
each blade, each leaf, always specificity.
It is a horse chestnut and not a willow.
In every paint stroke lies an umbilical cord.
You wait as John Brown rides to
his execution. You snug a woolen muffler
against your neck. The blamelessness
he sketched on a soldier's face.

"We only see what we look at," Berger says. "To look is an act of choice."
Pippin chooses
to touch the surface, only the surface
with his eye: mottled, speckled,
lined, curlicued, flattened by light.
Claim, he says, this rough
imperfect. Claim by eye, by breath,
by avarice what belongs to you:
the color red
every falling leaf, snow.

*I paint it exactly the way
it is and exactly
the way I see it.*

THE SUBTLETY OF BLUE

> His work isn't subtle. For instance, blues for the sky came
> right out of the tube, maybe with a little white mixed in.
> —Dave Mueller

Perhaps he understood—having lived between poles of black
and white—light's crude delineations. This is blue. This is yellow.

Perhaps the taxonomies of color hardly matter. The sky is blue or
blue as a dinner plate or blue as a blue-gummed girl. Corpse blue,

gas blue, azure, cerulean, cobalt, Prussian, Mrs. Stewart's Bluing, or
the blues a man feels when he's aching, and so low, so low,

or blue with a little white mixed in to temper the blue and make it
(like solitude or separation) blue but not perfect.

Perhaps imperfection did not matter to him. Given a length
of light, the eye—being fond of perfidy—will say

whatever you wish. Maybe he wanted the viewer uncertain or
wanted to make his viewer ponder: sky. A black man alters

a white canvas. He paints vapor trails, clouds, vastness.
And this is the point: he uses any damn color he chooses.

V

YOU HAVE REQUESTED AN EXPLANATION
OF THE PICTURE

The pictures which I have already painted come to me in my mind, and if to me it is a worth while picture, I paint it. I go over that picture in my mind several times and when I am ready to paint it I have all the details that I need. I take my time and examine every coat of paint carefully and to be sure that the exact color which I have in my mind is satisfactory to me. Then I work my foreground from the background. That throws the background away from the foreground. In other words bringing out my work.

—Horace H. Pippin

"Ed, you know why I'm great?" I said "No," because I really wanted to know. I said "No. Why?" He says, "Because I paint things exactly the way they are. . . . I don't do what these white guys do. I don't go around here making up a whole lot of stuff. I paint it exactly the way it is and exactly the way I see it."

—Ed Loper

DOMINO PLAYERS, 1943

Tiles, stones, spinners, bones, bricks and men—dominoes
spilled atop a kitchen table knock like teeth, like tumbling
die, each tile ticked into place. In an oil painting
by a crippled doughboy, twenty-five years after the war,
two women and a child play dominoes, play and stir the tiles,
while the child, fulcrumed between the two, looks on, his eyes
like knives, like stabs of paint. His granny watches, piecing
her quilt, lifting and snagging her needle like a query.
This is recollection's accounting: bare lathes
and cracked plaster, smoke-hued walls, a cast-iron stove
fanged with flames, the window and its ratty shade,
a wooden floor agued as an old man's bones.

But displayed on a doilied shelf, a clock and a kerosene lamp,
time and fire, one the mirror of the other, all things burning,
all hours trimmed like a cotton wick in a globe of kerosene.
In this painted room, Clotho draws her sanguine thread
while at her feet scissors lie angled on a swath of red, a sign:
All breath is thread and all flesh shroud, or *all breath
tether and all flesh a bridle pieced from make-do and remnant.*

At the painted table Lachesis sits in a polka-dotted blouse,
her waist strings carefully cinched and carefully bowed.
Worrying a long-stemmed pipe, Atropos measures breath
into skeins of smoke, smoke to drift over the child's head,
the bluish brume that will rise over the sumps and shell holes
of Meuse-Argonne, the smoke of Château-Thierry and Séchault,
doilies of smoke that will clot the scalded lungs of fallen boys.
But that drifting smoke is far away. The child knows nothing,

nothing of how men will topple like dominoes, like black
tiles above a blackened earth, how the black rain
will beat black notes against their brows. The child

only watches, only waits, only listens through the long
rounds to the tiles' bump and toothy-click, to the scissors'
snip, to the rocker's beat against the crooked boards.
A wounded vet lifts his brush and studies the painted child
who cannot see him, cannot feel the shrapnel-blasted arm
that lies ahead or the pressure of the brush against his brow.

THE SATISFACTIONS OF A LIMITED VIEW

 As if to deny
distance or *viewpoint*, as if to refute continuities
of space and linear perspective—the artist
has drawn the window's shades. The windows
are architectural, an aspect of wall or, more exactly,
negation or cataract. A painted shade on a painted window

in a painted room asserts that there is nothing
beyond the seeming *now* or *here*, beyond
the quaint vanities of our senses. I am

because I see. I am what I have seen.
There are no vanishing points, for we fear
abandonment. A shaded window begs: stay,
or rather—look, or rather—I give you what I have.
The blackened window denies separation, refuses
difference. Closed: the doors. Drawn: the shades.
Why recollect? Outside: chaos. Inside: boundaries,
a small space to move in, much more than we need.

TOPOANALYSIS

Asleep, 1943

Topoanalysis: "the systematic psychological study
of the sites of our intimate lives."
—Gaston Bachelard

This is his childhood. This is Goshen.
This is the room of play and prayer and griddle cakes,
where women scrubbed brown babes in wooden tubs,
patched quilts, braided rugs, ordained cleanliness,
and smoked clay pipes for ease.

Atop a quilted pallet, children sleep. Someone
has already listened to their prayers and said amen.
Someone has tucked the covers tight, stirred
and banked the embers against the night.

This is his childhood. This is Goshen.
This the room he painted to cradle the boy he was.
The painter's step, the sleepers think, is the floor settling.
His breath against their skin, they think *a draft* or *the night's cold.*
And if the painted boy should open painted eyes,
he'll think a shadow, or the Sandman, or *if I should die before I wake*—

> Thus, very quickly, at the very first word,
> at the first poetic overture, the reader
> who is 'reading a room' leaves off reading
> and starts to think of some place in his own past.
> —Gaston Bachelard

At the first poetic overture, the house is gone or is here still,
though no one will answer, or a child will, and the screen door
that never stayed closed invites the sun, and smoke-staunched air,

and yellow dust, and pine-rot as it always did. Inside the house
that is, or was once, there waits a cast-iron bed and a child
and straight-back chairs. A child schooled by silence, who knows
that soundlessness and *shhhh* are motes of dust, are red as cellar dirt.
Silence can smell like raw earth and the down, down darkness
of a well. Hush, and still, and without noise are tiptoe
and tadpoles sperming against a concrete bank. Silence

is a gathering of goldfish under lusters of waterlilies, white
shining, white-scalding, a white silence that sets everything
afire. Silence is what the child called lonely and pulled
from her pocket with a soil of cornbread crumbs to feed the goldfish.
Salty crumbs will kill the fish, but the child refuses to believe it.
Poor child, poor fish, poor woman peering into the depths
of a floating world, seeing hunger and thinking its ache
the same as silence or lonely, trying to sate each empty mouth
with this one small act: a spill of cornbread coins, giving all,
saving nothing, refusing cause or effect, refusing
to believe death small enough to fit inside a pocket
or a child's fist, refusing to believe the lessons
of death's silence are any graver than those already learned.

And here in a painted room: cracked plaster, the stove
propped atop a stack of bricks, torn shutters, children sealed
in painted warmth, winter hidden by a painted shade.

VICTORIAN INTERIOR, 1945

The war-blasted limb that made this room
must have trembled at its symmetry:
white antimacassars on black armchairs.
Amidst perfect order: exuberance: roses
red, yellow, and white above a web of lace.

Yet in another room, unseen and far away
a smaller hand also trembles and lifts
from the mothy dark scallops, stars,
points, and ruffles meant to be shaped
and starched, but flaccid as jellyfish: doilies.

Without tenderness, how do we touch
the exquisite? How do we hold
these delicate webs without linking lost years,
without recalling the stupid joy
of a crochet stitch—of bobble braid
and popcorn waffle—the frail
entanglements of hands and eyes?

This is a Victorian interior, nearly
thirty years after the war. Here the eye slows,
and shell-bursts of roses stun the ears.
This is a kerosene lamp, and these are walls sooty
with gun smoke, and these are the red
poppies of Flanders Field, and these black-robed
judges—two sofa chairs, scales in a formal parlor—
parse their sentence. The right chair asks,
what did you do? The left chair asks,
what didn't you do? Here between loveliness
and darkness lies no man's land, a white doily.

In the Meuse-Argonne, at Séchault,
Belleau Wood, and Bois d'Hauzy these shadows,
taken by shell or bullet or bayonet,
lay as they fell on dark earth, still and ordered
as doilies in a Victorian parlor, another,
another, another, another, and the withered arm
that wields this brush soothes paint
across an inadequate canvas, and in the faltering
light an urgent heart murmurs, *go ahead, go ahead.*

1939

The Getaway, 1939, also known as *The Fox [The Get-a-way]*

Try to ignore the connections between the invasion of Poland,
a sorceress crushed beside the curb of a yellow brick road,
and a 1939 painting by a Negro folk artist of an escaping fox—
fox as sneak-thief, spirit-animal, shape-shifter, ambassador
of ghosts, fox as sign, how death steals and steals away.

Dark sky and torn clouds, the snow, the axe-colored creek,
Ol' Brer Fox with Massa's best settin' hen pinched tight
between pointy teeth, a little some'm-some'm the fox
thinks he is righteously owed and has artfully gained
with stealth, as history is ultimately a chronology
of grand larcenies and petty thefts, the bones of prey animals
picked clean by kit and vixen. History is the fox.

But art too is theft. Mark the rapacious brush (pointed
like a fox's tail). Mark the rapacious eye (vision's
feral skittishness). Mark the rapacious canvas
(like the henhouse, after the fox has left). Lift a brush, snatch
the unwary eye, alter borders for *lebensraum*,
and *you'll be his- you'll be his- you'll be history!*

A watercolor painted by Adolf Hitler is auctioned
for less than Dorothy's ruby slippers. After all, a pair
of ruby slippers could be enchanted kits, fox spirits
bearing missives from the dead, or exhibit items
stolen from a display of several thousand little shoes
in a Polish *Konzentrationslager*. A pair of ruby slippers
could be the ears of the fox in Pippin's *The Getaway*.
History is a tale of shape-shifting and unlikely connections,
or art is the fleeing fox and history dangles from its mouth.

THE TRAPPER RETURNING HOME, 1941

After the painting by Horace H. Pippin

A hunter might keep his enchanted animal-wife if he hides her
pelt so she can never find it and return to her old life.

White miles, white miles he walked homeward,
but still she will not come to him. Her nostrils flinch
from the man-smell of musk and metal that lingers
for hours and stalks the borders of her skin, even after
she bathes and pours well water or snow melt or wash
from the Brandywine over every part. Even if she rubs,
desperately rubs, thigh and breast with silt or sharp-cindered
ash from the hearth, his smell stays. Only the pine boughs
piled atop his bed, the sweet fern, woodruff, and drying
herbs gathered in the months before the snow, only
the earthy nest that she built with unaccustomed fingers,
nearly hide his soured sweat. If she lies unmoving,
she finds the smell almost endurable. She stays,

as she must stay, with his belongings,
the table, chair, bed, chest, clothes, the dress he first
wrenched over her head and flailing arms. The season
turns and still she cannot find it—the soft brown pelt,
stippled with flecks of white, the dangling legs
and hooves as sharp as rain on flagstone—though
she's searched, searched everywhere.

She has not found it and cannot enter the woods again
or, still beneath an eave of moonlight, slip unfettered
into a herd of shadows. Searching, every day
searching, yet she cannot find it. But he's home now.
She watches as he shoulders the door aside
and stomps the snow from leather boots and throws

a carcass at her feet and heavy pelts of brown,
or black, or silver, though not her own. She lifts
the largest pelt and presses it against her belly, feels
its weight and emptiness. He says, "Nearly nothing
left in those woods to trap," or "Snow's getting deep."
Her eyes beg: Where? He turns, snow falling
from his shoulders. He scrapes his hands before the fire.
"Looks like another hard winter," he says,
as if she asked not where—but why.

LILIES, 1941

Could they, because of their folding
or unfolding, be any more erotic, or,

because the eye can almost
enter their white flutes, more conflicted?

Little nuns in strict wimples, buds
thrust up from carnal soil.

See—at the center—
amidst the tubular scrolls: darkness, void,

and fear daunted by calla lilies rising
from a porcelain bowl above a white doily.

Crude paint and yet discernment: the eye's lechery,
the mind's flowering roots, flesh as cornucopia,

throats lifted in song, the trumpets of Torricelli.
Four calla lilies thrust from painted earth.

IN A PAINTED ROOM

Domino Players, 1943

Inside winter, a cold that is not of ice or snow
 or duplicitous light. Outside, where night presses
against pain and pane and polka-dots of snow,
 and inside again, inside a room, inside
a man looking back, looking inward, looking in
 a room where women play dominoes, quilt, and watch
over their child. Outside, outward, what remains unheard.
 Inside, the friction and slide of tiles
across a wooden table, the click of tarnished teeth
 on the tip of a pipe stem, sighs of smoke, the tick
and tick of a steeple clock stitching the hour, the crepitation
 of a wood fire, a rocker's bump-a-beat,
bump-a-beat. But outside, outside the painted room,
 outside paint and turpentine stench, but inside
the man painting, painting outside the room, outside his labor,
 Ella sings, *"My heart and I decided. We'd find heaven,*
blue heaven too secluded with you." Outside, Sugar Ray snaps
 whiplash against the jaw of Jake LaMotta. Amos
and Andy head to Chicago with $24.00 and buttered ham 'n' cheese sandwiches.
 Outside, another man is broken, broken
apart. Outside. Inside. Inside, a man who sits before a canvas. Inside
 the canvas waits a room, a room where nothing alters
or enters, where a child's gaze stays outward, beyond. Every threshold
 is hallowed ground, and these portals too:
the wooden frame, the canvas, the remembered room, the open eye,
 and every stroke of light.

WHY, OH WHY, THE DOILY?

> The lace doily (or antimacassar) was to become as persistent a
> symbol in Pippin's later work as the classical torso in Chirico
> or the jungle in Rousseau. Whether it represented some unat-
> tainable respectability or was seized upon solely for its decora-
> tive mosaic, we have no way of knowing: but toward the end of
> his career its use became pervasive to the point of abstraction.
> —Selden Rodman

> Why, oh why, the doily?
> —Elizabeth Bishop, "Filling Station"

1

In a slant of light, a woman crochets a doily,
working the hook in and out. She wraps
a thread of cotton floss around
her index finger, almost
as if she were writing. The words fall
from her crochet hook, linked
into white lace, a white page.

Words tangle in stringy ink,
almost manic, a speaking in tongues,
looped, caught, tucked under a stitch
of breath. Memory rises as if
it were a doily of lace, beautifully edged,
holding what once mattered.

2

Memory snags on a doily's lace, a ring game of thread—
Put your hands on your hips, let your backbone slip.
The past wears the body of a girl-child to skip, spin-
dizzy, fall and leap up again. There is resurrection
in a jump rope's twirl. The past tosses the unseen
like a stone, then, scooping it up, claims it, the present
a pip, a prize for having journeyed. A doily starched,
shaped into fullness, the hem of a child's skirt as she twirls,
twirls and falls. Our first sex is with the earth that pulls us
down, that holds us against its skin as a doily draws the eye.

3

From fiberglass, an artist crochets doilies of resin.
"Arte Povera," she says, "Chaos Theory,"
"the Fibonacci sequence, the numbers *Pi*
and *e*, and Pascal's triangle." Fiberglass chains
and joinings gather light and transform
into shining, into narratives of mathematical
precision, from simplicity into hybrid
space and form, thread and fabric, plane
and dimension, maker and made.

How measure a doily's self-similarities?
Unraveled, a doily is skeins of cotton thread.
Untwisted, the threads are fiber. Released,
the fiber drifts over a mill in Carolina or a field
in Alabama, over a cotton row where a rat snake
coils under the shade of a cotton plant, unaware
of a descending blade, how things fall apart.

Another artist links antique doilies, builds
sculptures, webs, womb-rooms, huge cellular
amoebas of chains *(sc in 2nd ch from hook*
and in each ch across for 34 sc). Elsewhere
a poet writes that a single doily is the cell
of an extraterrestrial organism. Objects drawn
past its plasma membrane are consumed.
At night, doilies levitate upward toward
their host colony, frequently mistaken for mist,
cloud formations, snow, or vees of geese.
Doilies have always been amongst us.

4

A man lies on top of a woman.

Which is the doily?

Which is a vase of clear water
filled with wands of weigela or lemon basil?

Which—the man or the woman—lifts this moment
above smooth flesh, bare and shining like still water?

5

Doilies are two-dimensional planes until starched
and shaped or crocheted with wire or words or breath.

Then they are architectural. Doilies are flat
like stepping stones, like old graves, like the known

universe before longitude, but they can be bowls,
mesh cages, or equations of hyperbolic geometry,

say Russian kale or a coral reef, say old grief
or a black woman's hair on a humid day.

6

Consider the doily, a plane, space made lovely,
space that is and is not, form that is and is not.
Atop a doily you may place anything of value,
anything that you want to beguile the eye:
a porcelain soup tureen from the Azores,
a lead crystal candy bowl, the photograph
of a soldier in uniform. Consider the doily,
how it shows what does and does not belong
to you, what little you have, as if, surprisingly,
there were always poverty in such display.

7

646.42 Doilies, The Art of
Doi

 Patterns, repetitions, skeletons of lace used for display, to protect,
 proclaim, give status, attract the eye, give access, to prove, as she said,
 that *Somebody loves us all.*

 Subject headings:
 1) lacemaking 2) crochet—history 3) handiwork, women

 (see also geometry)

8

The doily knows only one word: *Behold!*

9

Questions the doily asks:

> 1.0 Is space a material thing in which all material things are
> to be located?
> —Bernard Tschumi, *Architecture and Disjunction*

1.1 If doilies are material spaces, should space be understood as form?

1.1.1 If doilies are intersections of form and space, what is the boundary between conceptualized space and the space of the material doily?

1.1.2 If the doily's purpose is display, does an object placed within or atop a doily represent the measure of its display? Do doilies display, at every moment, all objects in any space? We display the doily. Does the doily display us?

1.1.3 If a doily contains an infinite number of spaces, does display alter the perception of space?

1.2 Doilies replicate gardens: lilies, roses, palm fronds, carnations, forget-me-nots, daisies, as gardens themselves replicate the wild and fecund. What is consumed in a doily's replicated garden?

1.2.1 If doilies are figurative gardens, are they subversive in the context of the large-scale monocultures of modern agribusiness?

1. 2.2 As metaphorical garden and embodied paradise in which divinity and sexuality are not separate, do doilies deny same-sex or heterosexual desire? Are they petitions to an absent divinity?

1.2.3 As metaphorical gardens, doilies feature flowers, the classic emblems of sexuality. Is the doily a means of seduction?

1.3 A doily belonging to Eva Braun is sold at auction. A Negro folk artist paints pictures of his wife's doilies. A black woman passes on a cardboard box, filled with her mother's doilies, to her daughter. Which doily does not represent memory?

1. 4 Are doilies beautiful because they balance absence with presence?

1.4.1 If doilies are hybrids (form and formlessness, repetition and deviation), is what composes a doily also hybrid—space, connection, beauty?

1.4.2 But if the doily is itself beauty, as well as a marker for beauty, does it compete for the space allocated to women? In making a doily, does a woman replicate *woman, feminine, womb, girl?*

10

In *Spring Flowers with Lace Doily,* 1944
Pippin paints gladioli, chrysanthemums,
roses, and orange poppies over a doily
as intricate as a spider's web or altar cloth,
a pictograph across a sandstone cliff.

Wild abundance or what is only lovely?
He argues with himself

about the divine
 and the earthly,
about chaos
 and order—he can't decide.

He paints a doily, labors to show
every intersecting thread, each thread

a path untaken, a path that might have
made all the difference, each thread
a journey. He paints the spaces,
the interruptions of pattern that are also pattern.
His doilies look like nets, sieves,
or the aerial cartography of a vast irrigation system,
labyrinths where there are monsters,
but also, surely, gods. And so the flowers,
and so his doilies, and so his petition.

WHITE FLESH

Christ (Crowned with Thorns), 1938

How sad this Christ, how mournful
his salt-gray flesh, the gray nipple
on his bare chest, small flesh circle

exposed as if to suckle.
White flesh, colorless, ash, ash,
remnant of terrible flames, a body

more wick than flesh, more
winding sheet or wordless page.
Pity him, the modest eyes

that ask for nothing, cast downward
but yet accusing—see the thorns, the blood,
his stripped body, that awful nipple,
naked as an eye, reminder
that we are mammals

—the cruel theatre, suffering,
despair, humiliation. But not
painted whole, no limbs, no belly
to hunger or to sate, no manhood.

He does not look up or outward,
nor into the measure of other eyes,
eyes equal to the thorn, the scourge,
the brush scraped against a canvas.

THE WARPED TABLE, A STILL LIFE, 1940

Flower not yet faded.
Without blight the fruit.
No shadows or tarnished light,
no raveling of peel,
no skulls or goblets, tipped

—a feast, enough to fill the table,
nothing yet chewed, sucked, bitten.
We are not cast from paradise.

BIRMINGHAM MEETING HOUSE

From 1940–42, Horace H. Pippin painted the
Birmingham Friends Meetinghouse four times.

Now near,
 now far.

Now closed,
 now open.

Now spring,
 now fall.

Now the sky,
 now hardly sky at all.

Now the stone,
 or more the shutters and the door?

Now a canopy of leaves,
 now thin-leafed, bare.

Now looking at, or looking toward,
 but never entering, the door.

Now a mind seeing, now a mind looking back.
 Two minds? Four? More?

Now the artist's gaze,
 and now the changing light.

HARMONIZING

Summer?
>Yes, the trees gravid with leaf,
>a pelt of grass beside the pavement.

A dull blue sky—evening?
>Aging of the artist's paint, the flatness of the self-taught,
>or the paint he had available.[1]

Early? Late?
>Early still. The streetlight unlit.
>No lights in the windows. No shadows.

Hot? A hot summer day?
>Striped V-neck, a handkerchief to wipe a brow,
>bib overalls, close-cropped hair and long sleeves,
>a jacket over a cotton shirt—cool still,
>maybe early summer, possibly spring after all.

Men on a corner?
>Singing.[2] Open-mouthed.
>One lifts his hand like a baton.
>One drapes his hand over another singer's shoulder.

A quartet then?
>Four men, African Americans[3]
>in a 1944[4] oil painting by Horace H. Pippin.[5]

The wooden fence?[6]
>Better acoustics? A stage?
>A cleaving of secular from sacred?
>A structure like those dovetailed notes.

And the knots in the fence?
> Mouths
> widened to lift an ascendant note.

And the object at the singer's feet?
> A miner's lunch bucket?[7]
> The lunch that they will share afterwards, or have shared?
> Is the man in overalls a miner?[8]

> The eye savors uncertainty, perhaps.
> Maybe the lunch bucket suggests we can be sated by symmetry.
> Maybe our ears are also fed by painted music.

[1]Pippin used lower quality paints and possibly even house paint in his early work.

[2]Acappella: an Italian term for in the way of the church or chapel.

[3]The barbershop quartet is an art form that originated among African Americans and was popular in the 1930s–1940s.

[4]In the summer of 1944, Allied Forces began the D-Day offensive. 1944 also saw the continued decline of lynching in the United States. Two lynchings of African Americans appear on record for the year.

[5]Folk artist. See also outsider artist, marginal artist, raw artist, self-taught artist, organic artist, intuitive artist.

[6]The corner of West Gay and Hannum Street in West Chester, Pennsylvania.

[7]Miners' lunch pails had separate compartments. The top half carried soup or coffee, while the lower half might carry a meat pie.

[8]Pennsylvania anthracite mines required lengthy apprenticeships by law. That requirement had the effect of barring African Americans who traveled North during the Great Migration from finding work in Northern Pennsylvania mines. African Americans (when they could find work) tended to be hired by bituminous coal mines in Southern Pennsylvania.

CONTEMPLATION, THE ART OF

Man on a Bench, 1946

 The bench is *gone by,*
and *mind goes back.* The old man sitting on the slats
of a red bench is the *now* or *that right knee hurtin'*
like a son of a. . . . The white squirrel posed under yellow leaves
is *might be,* or *Honey, I don't know,* the wild-unexpected
already leaping away. The red bench is the seed
of the wooden bench with cast-iron legs beside Anna's pond.
Come with me, she says, come and feed the fish.
The koi and catfish rise at the custom of her steps, rise
from depths her hands have shaped.

From cupped palms and a coffee can, she sows
the mealy seed that bears her skin's scent, a flesh-salt
sucked by greedy lips. I love to watch them, she says.
The fish rise, and that inwardness rises, which is wary
and quick, which must be enticed. What to name it?
What makes it leave its shadowy shelter? The koi
reach their articulate lips to draw into small bellies
pond water, sky, passing birds, and a plane's contrail.

Contemplation, the art of, what she learned from her father.
The pine bench that her father built to sit beside a pond,
a grace shaped by back and breath to secure privacy,
a stillness for shaking the mind's traces, *gee* or *haw.*

In Anna's yard, to a wooden bench, ghosts come,
ghosts summoned from dust and distance. I cannot see them,
but I know that red dirt spills from the corners of their mouths
and yellow clay crumbles from their hems. Anna's ghosts
sit beside her and speak as they used to do, songs mistaken

for the drone of dragonflies or the filter's burble. In a pond's
depth, the fish hang in liquid air, their bodies like palms
pressed together in prayer, bodies, like our own, shaped
into petitions. *Chil', grief is a catfish, got a belly swoll with rot.*

Anna's ghosts rise and leave as they always do,
shadows now, or sighs, or sunlight bending westward and away.
We listen, the two of us, to the play of water
over plastic rocks, water rising and purling down
plastic steps into a plastic pond, a ceaseless
cycle. Loss—what is loss? Now—what is now?

In the painting by an obscure folk artist, a man sits
on a red bench inside a public park while his ease
draws the eye as fish are drawn, a man taking his time,
sitting as a king might, as if satisfied, though
his eyes, cast downward, stare at nothing,
and the season hangs low over him like a golden net.

NEWLY DISCOVERED PORTRAIT OF AMERICA'S FIRST BLACK PRESIDENT BY HORACE H. PIPPIN (1888–1946)

Distorted, of course, but discernible: the thin red-brown lips
pressed firm, the mole rising beside his nose, the yellow-brown
skin and bituminous eyes bright, afire under a smooth brow,
and the silvering crinkle of gray-black hair, the slender face.

In the background, the white columns of the South Portico,
the green lawn, the green leaf-burdened trees on either side,
a seam of red roses, each one a curl of paint, and beneath
the eaves of an oak (like Hicks's *Peaceable Kingdom*)
black soldiers in puttees and Adrian helmets lofting

Old Glory and holding French Berthiers, while away from them,
under the portico, behind a pulpit, a black preacher lifts
his hands as if to mop a brow or beseech, and smaller still
and almost hidden under the limbs of a magnolia, four little
brown girls in Sunday dresses, each carrying a white rose.

Each figure on the same flat plane, no depth, no distinction, no
vanishing point, no linear perspective. Enter like history,
anywhere. One easily imagines his brush lifted,
right hand cupped in the left, struggling to get every detail—
supposed and then composed—flags, the diamonded tie,

dignity, pride, solemnity. The four little girls do not look
at one another. The preacher addresses a crowd no one sees.
The soldiers peer outward into a far distance. Only
the key figure stares outward and refuses to deflect our regard.
Unsigned, but as you can see, surely his work,

the exacting brushstrokes, the elegant composition,
the way the image reaches beyond the canvas, rising, lifted up.
We expect vigorous bidding for this unknown work, well-preserved,

prophetic with a primitive's engaging simplicity—certainly
the jewel of any collection, a sound investment, sure to appreciate in value.

VI

NOW I KNOW HOW YOU FEEL ALONE

His white shirt, gray pants were kept sparkling clean and in good repair, for Pippin's appearance was more important to his wife than his "so-called" Genius. She had little faith or belief in the sudden fame the world offered her husband in appreciation of his "hobby," painting.

"Get these things out of here, now, Horace," was how she put it one day when I visited. She'd been doing the wash in the small room behind the kitchen and was preparing to set the table for dinner. She was a hustler in her home, a "buck sergeant."

—Tom Bostelle

Dear Mr. Carlen,
I wish you would send me a report of the first show, that we hade, as soon as you can, for my wife is made at me for it as I can not tell how we came out. So will you do this for me; plees, I am woraking hard to have 4-or 5-pichers ready by March, if I can, so I will thank you vearry mutch, Horace Pippin.

EROTICA

Nothing extravagant
or loud—

a scalloped collar, altar-white,
dress the color of the sea. Or rather,
the gray of coming rain, of winter ice,
the blade of a kitchen knife.

Nothing to distract, nothing
to pull the eye away from or toward—

Portrait of My Wife, 1936,
oil on fabric, by Horace H. Pippin—

his wife who sits with no space
between her body and its frame. Framed
by stillness, she will not move.
How centered she is. There is nothing else.

His eyes touch, and touch again, her face,
her hair, the swell of her shoulders,
searching the geometries of her flesh.

With a slanted brush, he tips her eyes downward,
gently removes her hands. Still
she does not look, will not lift her eyes
or whisper through tight lips yea or nay.
She stays patient before the measure of his gaze,
the way, with licks of paint, he dresses her,
with a turn of his eye covers,
or uncovers, the canvas of her skin.

DEFINITIONS

for Horace Pippin and Jennie Pippin

Load

Dead weight
heaved over barbed mud,
dead men, dead buddies, dead
bodies. Men drag broken
bodies over shell-broken
wastes. *Over there,*
over there—

Don't leave me.

Loads

Wash baskets, washtubs, washboards.
Miss Ann's and Mister Charley's
mounded into piles and sorted
by color, by delicacy, by soil.
Sweat, petals of shit,
dream-spit and discharge,
lipstick, face powder, accident.

Got a gal get a shirt so clean
it'll blind you.

Fold

Fold, fall,
the body falls.
A soldier's body folds
over a snag of wire.

Fold, fall,
the body falls. Fold—
a crease, the letter folds
and unfolds. Its words
wear thin. Lonely—a fold,
a fissure, a fracture
in the right ventricle, feelings
fold, the body
folds, falls, dies.

Folds

Fold sheets and shirts.
The body's folds: neck, belly,
an arm, a leg. The breasts folded
over the ribs. Hands folding, folded, full.
Doesn't the body make a good coat?

Lips fold over a word,
and every word folded,
made easier to carry,
requiring less room,
easy to store, easy to save
for later.

Blues

Blue (spells).
The mind turns trench rat, turns
scavenger, sneak.

Blue smoke rises
from a heated poker, a poker
splitting wood grain, gouging
burn, scarred with story.

Blues sorrow-spilling
into restlessness. Blue
and blue spells, blue
like the air above the Argonne
blued with phosphene, choking.

Bluing

*White fabric turns yellow or gray with age
and repeated washings. Bluing counteracts these
ugly shades by adding a blue-whiteness to make
them snow white.*

Mrs. Stewart's Bluing to whiten and temper stain,
lighten sheets yellowed by sweat, salt,
and compressed skin.

Gilt, fool's gold, residue,
the body's mark, its yellow soil.
Yellow clay, flesh-dust
that the wind will not scrape nor water
scour. The mind and its stains.

HOW TO USE MRS. STEWART'S BLUING

*Tip the bottle and shake out enough drops
into the last rinse to make water light sky-blue.
Mixes instantly—no chips or flakes to dissolve.*

Lie

Even on his stone,
they got it wrong.

Lye

Leach of ash, alkaline, caustic,
lye for soap, lye for strong stains
to bleach, abrade, erode soil

and body oil. He says she doesn't
need to take in wash. He says
his picture-making can support them now.

But nothing cleans like lye soap,
bleaches white, scours out.

Red

Cadmium selenide. Cadmium sulfide.
A rose exploding its red shrapnel, red
blasted across a stretched canvas,
the brush a bayonet tipped with red
to stab, stab, stab against the canvas.

Red

Red was thigh, breast, belly, or back.
Flesh was red.

Red roses on a cotton sheet:
blood was red.

Red the folds of the labia:
Even on brown skin, a blush is red.

Doilies

Doilies rotting in a muddied field, doilies
draped over barbed wire, the doily
that fell on top of him that he couldn't lift. Doilies
of phlegm fear spat atop gray mud: doilies
of salt, doilies splayed under drifts of gas,
the doilies of smoke left after exploding shells.
Light falls on dead eyes, flat, white as doilies.

Doilies

She held the hook
like a question mark,
shaping answers
into roses and daisies,
into webs or constellations,
into a garden where a woman sits,
hands cupped empty,
two shells, two doilies
bearing bouquets of light,
two knots nothing will undo.

Jonesin': To Crave

Memory,
making pictures,
his old self brought out,
more pictures to sell.

Whiskey,
breath-stink and slur.
Put him drunk on a trolley home.

Jonesin': To Crave

Order,
scrubbing, making clean,
pennies a pound, a load.

Amphetamines,
pounds lost, body lost.
Say she went out of her mind—

More, one more, *on the house.*
More,
still not enough.

smaller, thinner,
less, all she could do
but never enough.

COMMITMENT

Try to imagine the two of them, a man
and a woman, a husband driving his wife
to the state hospital for the mentally ill.
He is going to commit her. Imagine the hum
of the car's engine, the tires beating against
the road, or, if he has the window cracked
just a little for the air, imagine the wind.

Perhaps he makes small talk. He speaks softly
to reassure her, or maybe he says nothing.
Maybe she says nothing. She only watches
the road, already seeing the deer that might
step at any moment before their car, its head
breaking the windshield, the deer's wide eyes
and twisting back as it is thrown into the car.
The hooves strike her face, rip her cheek open.

This never happened. But imagine that it did,
that she felt the hooves' strike and her bones breaking,
her skin tearing like the deer's, both mangled.
No one to tell them apart: deer or woman.
Jennie, Jennie, Jennie. But she says nothing,
just looks at him wide-eyed like an animal
right before the swerving tires and the breaking.

MY WIFE IS NOT HOME AT THIS TIME

She went to Chester, PA. for weeks, to rest up so I am alone.
I cook also. Now I know how you feel alone.

Other nights, you pushed against me, foot against thigh, knees
into back, tumbled in sleep's undertow. Now I know how you feel alone.

Trouble comes as it always does, above an empty canvas.
My dark overseer: sorrow. Now I know how you feel alone.

The house shouts and rings with your voice, the things you said.
I can't make the words go. Now I know how you feel alone.

So many winter landscapes: storms, snow banks, ice.
Pippin, let the words fall like snow: Now I know how you feel alone.

VII

THEN A HAND LIGHTLY LAYED ON ME. THEN A STILL VOICE

Nearly fifty years after his death, Pippin's art still reminds us of how far we have *not* come in creating new languages and frameworks that do justice to his work, account for his narrow receptions and stay attuned to the risks he took and the costs he paid.

—Cornel West

Can the reception of the work of a black artist transcend mere documentary, social pleading or exotic appeal?

—Cornel West

BLESSING

For Horace H. Pippin, 1888–1946

When it comes to the gods always crippling those whom
they love most, as a way of ensuring the beloved both
fear and need—where, in fact, does it ever say so?
 —Carl Phillips

He would not have disagreed with you—
men washed in flames, boys chewing the clots
of melted lungs, slack hands cupping bloodied rain,
each soldier's body shaped into a burning bush,
into hallowed ground. Mindful of his own ruined shoulder,
he would not have disagreed about the ones
the gods held most beloved.

For he had *wrestled,* as the Bible says, *struggled,*
had felt his shoulder unhinged by an enemy whose face
he never saw. *Let me go for it is daybreak.* He had waited
the long hours, cold hours, beneath the rain-sopped weight
of a dead soldier, before an awful canvas. *Let me go*
for it is daybreak. He had wrestled with the dead
in the bottom of a shell hole and held on. *Genesis 32:26.*

And he said, I will not let thee go, except

 thou bless me.

Demanding a blessing and given one: inward-vision,
to look, and look again, wrestling through sleepless nights
sorrow's vast wings. A soldier who said *I will not*
let thee go, except thou bless me. Riven by a sniper's bullet,
he held on, refused to let go or to die. *Let me go.*
But he held his weakened arm in his stronger hand, gripped
the brush, pushed paint against an empty canvas, painted
what held him, what he held, refusing an ending.

NOTES

Biographical Information

Rather than trying to write a poetic biography of Horace Pippin, *Primitive* presents a poetic reflection on Pippin's life and work, and a critique of the idea that his life and his work are primitive. I have tried to stay close to the written record. Readers wanting additional information about Pippin's life and work may consult the materials listed below. Judith E. Stein's *I Tell My Heart* is especially recommended. I also recommend Celeste-Marie Bernier's *Suffering and Sunset,* which appeared after *Primitive* was completed.

Bernier, Celeste-Marie. *Suffering and Sunset: World War I in the Art and Life of Horace Pippin.* Philadelphia: Temple University Press, 2015.

Rodman, Selden. *Horace Pippin: A Negro Painter in America.* New York: Quadrangle Press, 1947.

I Tell My Heart: The Art of Horace Pippin. Edited by Judith E. Stein. New York: Pennsylvania Academy Fine Art and Universe, 1993.

Transcribing Pippin's Words

Pippin's spelling and punctuation are inconsistent and, given the condition of the surviving documents, not always legible. Where exact quotation seemed as if it could distract readers, I have regularized punctuation and spelling. Otherwise, I have quoted Pippin's writings as they appear in the original manuscripts, to the best of my ability.

Abbreviations

Autobiography: Horace Pippin Notebooks and Letters: Handwritten and Illustrated Notebook, entitled "Horace Pippin's Autobiography, First World War" (illustrated), circa 1920. Archives of American Art, Smithsonian Institution. Box 1 (pam) Folder 1. The Smithsonian's pagination differs from the pagination in Pippin's handwritten journal. I cite Pippin's pagination.

Handwritten notebook: Horace Pippin's Notebooks and Letters: Handwritten Notebook, October 4, 1920. Archives of American Art, Smithsonian Institution. Box 1 (pam) Folder 2.

Letters: Horace Pippin Notebook and Letters: Letters, circa 1943. Box 1 (pam). Folder 5. Archives of American Art, Smithsonian Institution.

Mihiel: Horace Pippin Notebooks and Letters: Handwritten Notebook entitled, "[t. Mihiel, Heaviest Champagne Argonne, Hear]", circa 1920. Archives of American Art, Smithsonian Institution. Box 1 (pam) Folder 3.

Rodman: Rodman, Selden. *Horace Pippin: A Negro Painter in America*. New York: Quadrangle Press, 1947.

11 NOW WHY DO I WANT TO GET UP SO HIGH: Died. Horace Pippin: *Time* 15 July 1946: 79.

The most important Negro: quoted in "Horace Pippin, 57, Negro Artist, Dies." *New York Times* 7 July 1946: 36, apparently based on Barnes, Albert C., "Horace Pippin Today." *Recent Paintings by Horace Pippin*. Exhibition catalogue. Philadelphia: Carlen Galleries, Mar. 21–Apr. 20, 1941, not paginated.

Now why do I want: Quoted from Woods, Joseph W. "Modern Primitive: Horace Pippin." *Crisis*. April 1946, 179.

13 "Picture of the Poet and Horace H. Pippin Before the Perigee": Italicized lines are quoted from Autobiography, 3.

15 IF A MAN KNOWS NOTHING BUT HARD TIMES: The section title quotes Pippin from "Work of Negro Painter Added to Encyclopedia." *Philadelphia Tribune* 7 Apr. 1945: 1, 16. Quotation from p. 16.

He does much of his work: Woods, Joseph W. "Meet Horace Pippin, Artist for Art's Sake." *Afro-American* [Baltimore] 16 Mar. 1946: 5.

He cannot be said to have actually studied: Stanford, Theodore. "Call Pippin Greater Painter than Tanner: Artist Uses Own Expression in Carrying on Work of Great Men, Dr. Barnes Says." *Afro-American* [Baltimore] 13 May 1944: 5.

Is a black artist like Pippin: West, Cornel. "Horace Pippin's Challenge to Art Criticism." *I Tell My Heart*. Edited by Judith Stein. Philadelphia: Pennsylvania Academy of the Fine Arts, 1993, 48.

17 "A Primitive Portrait": Art is dangerous: Apocryphally attributed to Duke Ellington. Attributed to Anthony Burgess by Robert Andrews, *The Columbia Dictionary of Quotations* (New York: Columbia University Press, 1993), 55.

I was scared to death: Quoted from Taimur Sullivan and Prism Quartet. "Billie." *Pitch Black: Music for Saxophones by Jacob TV*. Innova Records, 2008.

I paint it: "Horace Pippin's Art Honored in Book." *Philadelphia Tribune* 14 Feb. 1942: 11.

21 I'VE SEEN MEN DIE: The section title quotes Pippin as recorded by Rodman, 79.

At that time: Loper, Edward. "Interview by Marina Pacini." *Archives of American Art*. Washington, DC: Smithsonian Institution. 12 May 1989, 45.

Artist Gets Purple Heart: "Artist Gets Purple Heart 27 Years Late." *New York Amsterdam News* 29 Sept. 1945: 11.

23 **"Like This, Like That"**: Soldiers in the 369th Infantry referred to German soldiers by the term "Bosch."

25 **"Night March, 369th Infantry"**: Epigraph from Autobiography, 31.

26 **"A Canel"**: Epigraph from Handwritten Notebook, 4 Oct. 1920, 16.
Very flares: signal flares used during World War I, invented by E. W. Very.

28 **"Finding the Words"**: sirpen: Autobiography, 28.
Trees would snape: Autobiography, 11.
The shells would: Autobiography, 44.
The water ran down: Mihiel, 8.
It were in picess: Autobiography, 22.
I could heare: Autobiography, 34.
We would stick: Autobiography, 28.
I could not do: Handwritten Notebook, 45.

31 **"The Speller"**: The misspelled words in this poem appear in Pippin's war notebooks.

32 **"Forms and Shapes"**: he looked like he was scared: Quoted from Rodman, 79.
that afternoon we got in a cross fire: Autobiography, 48.
The next morning, I woke: Quoted from Rodman, 80.
Men were laying all over: Autobiography, 43.
found the body of men: Autobiography, 44.
then two shots broke: Autobiography, 32.
cold: Handwritten Notebook, 4.

36 **"Hard"**: Italicized lines are quoted from Handwritten Notebook, 49.

37 **"Horace Pippin's Red"**: Epigraph from Berger, John. "From John Berger 1.3.1997." *I Send You This Cadmium Red: A Correspondence between John Berger and John Christie.* Barcelona: ACTAR, 2000, not paginated.

41 **WAR BROUGHT OUT ALL THE ART IN ME**: The section title paraphrases Pippin from a letter. His actual words read: "so time went on - on tell the war of 1917. I went over seas with the old 15th n.y. inf. fighting no 369 inf; this Brought out all of all the art in me." From Letters. "Dear Friends." Circa 1943.

The war had been a shattering: Rodman, 10.

I made some seens of france: Letters. "Dear Mr Carlen." Circa 1943.

43 "Tell My Heart": Epigraph from Blitzstein, Madelin. "The Odds Were Against Him." *U.S. Week* 26 Apr. 1941, 12.

44 *"Losing the Way,* 1930": *Nel Mezzo del cammin:* Alighieri, Dante. *The Divine Comedy of Dante Alighieri.* Trans. by John D. Sinclair. New York: Oxford University Press, 1939, 22.

Teribell grond of sarro: Handwritten Notebook, 2.

45 "Prophet": Epigraph from Gurin, Ruth. *"Oral History Interview with Elizabeth Sparhawk-Jones, 1964 Apr. 26," Archives of American Art, Smithsonian Institution.*

46 "Surface, Decoration": The visual design of this poem plays variations on a typographic design by Benjamin Lutz in Lupton, Ellen. *Thinking with Type: A Critical Guide for Designers, Writers, Editors, & Students.* New York: Princeton Architectural Press, 2010, 118.

We only see what we look: Berger, John. *Ways of Seeing.* London: Penguin, 1972, 8.

I paint it exactly: Edward Loper, "Interview with Marina Pacini," 12 May 1989, Archives of American Art, Smithsonian Institution, Washington, DC, 44. Typescript.

47 "The Subtlety of Blue": Epigraph from Mueller, Dave. *Daily Local News.* West Chester, Penn. 8 June, 1979.

49 YOU HAVE REQUESTED AN EXPLANATION OF THE PICTURE: Section title from a letter by Horace Pippin. 5 Feb. 1945. Addressed to "My Dear Friend." Carlen, Robert. Carlen Galleries, Inc. records. Smithsonian Archives.

The pictures which I have: Cahill, Holger et al. *Masters of Popular Painting: Modern Primitives of Europe and America.* New York: Museum of Modern Art, 1938, 125–126.

"Ed, you know": Edward Loper, "Interview with Marina Pacini," 12 May 1989, Archives of American Art, Smithsonian Institution, Washington, DC, 44. Typescript.

54 "Topoanalysis": Epigraph from Bachelard, Gaston. *The Poetics of Space.* Trans. by Maria Jolas. Boston: Beacon Press, 1958, 8.

Thus, very quickly: Bachelard. *The Poetics of Space,* 14.

58 "1939": *you'll be history:* Harburg, Edgar Yipsel. "Munchkinland." Song. *The Wizard of Oz,* 1939. Film.

62 "In a Painted Room": My heart and I decided: Fitzgerald, Ella, performer. "My Heart

and I Decided." By Walter Donaldson. *The War Years (1941–1947)*. New York: GRP Records, 1994.

63 "Why, Oh Why, the Doily?": First epigraph from Rodman, 7.

Second epigraph from Bishop, Elizabeth. "Filling Station." *Elizabeth Bishop: The Complete Poems 1927–1979*. New York: Noonday Press, 1980, 127.

Put your hands on your hips: from a traditional African American ring game, Little Sally Walker.

Section 9, "Questions the doily asks": after an essay by Bernard Tschumi. "Questions of Space." *Architecture and Disjunction*. Cambridge, Mass.: MIT Press, 2001.

79 NOW I KNOW HOW YOU FEEL ALONE: Section title quoted from Letter from Pippin to Carlen, 4 Sept. 1945. Carlen Galleries, Inc. records. Smithsonian Archives.

His white shirt: Bostelle, Tom. "Bostelle Recalls Early Encounter." *The Kennett Paper*. 18 Feb., 1988.

"Dear Mr. Carlen": from an undated letter by Horace Pippin to Robert Carlen. Carlen, Robert. Carlen Galleries, Inc. records. Smithsonian Archives.

82 "Definitions": Directions for Mrs. Stewart's Bluing quoted from a vintage bottle of Mrs. Stewart's Concentrated Liquid Bluing, Mrs. Stewart's Bluing Corporation.

86 "Commitment": Epigraph from Rodman, Selden and Carole Cleaver. *Horace Pippin: The Artist as a Black American*. New York: Doubleday, 1972, 88.

87 "My Wife Is Not Home at This Time": She went to Chester, PA, for weeks: Letter from Pippin to Robert Carlen, 4 Sept. 1945. Carlen Galleries, Inc. records. Smithsonian Archives.

89 THEN A HAND LIGHTLY LAYED ON ME. THEN A STILL VOICE: Section title quoted from Handwritten Notebook, 47–48.

Nearly fifty years after his death: West, Cornel. *Keeping Faith: Philosophy and Race in America*. New York: Routledge, 1993, 66.

Can the reception: West. *Keeping Faith*, 55.

91 "Blessing": When it comes to the gods: Phillips, Carl. "Southern Cross." *Speak Low*. New York: Farrar, Straus and Giroux, 2009, 4.

⊞　⊞　⊞

ACKNOWLEDGMENTS

Primitive is indebted to numerous archivists, librarians, and museum professionals, and especially to the generosity of the following institutions:

Archives of American Art, Smithsonian Institution
The Barnes Foundation
Brandywine River Museum
Chester County Historical Society
Goshen Public Library and Historical Society
Pennsylvania Academy of the Fine Arts
Philadelphia Museum of Art
The Phillips Collection
University of Illinois Library

I am grateful for the support of the Rona Jaffe Foundation and the Department of English at the University of Illinois, including its former head, Curtis Perry. Special thanks to Pauline Loper; Pamela C. Powell of the Chester County Historical Society; Ann Roche of the Goshen Public Library and Historical Society; Debra M. French of *County Lines Magazine;* and to Elizabeth Hearne and Molly MacRae. Thank you as well to the many people who helped in so many ways over the years I have worked on this book. Apologies to anyone whose name I have inadvertently left out.

I am also grateful to the editors of the following journals where some of these poems previously appeared, sometimes in earlier versions:

"Picture of the Poet and Horace H. Pippin Before the Perigee." *Connotations Press* (July 2012).

"A Primitive Portrait." *Prairie Schooner,* 88.2 (Summer 2014): 43–45.

"Fire." *Angles of Ascent: A Norton Anthology of Contemporary African American Poetry.* Ed. Charles Henry Rowell. New York: W. W. Norton, 2013. 459–60.

"Horace Pippin's Red." *Indiana Review* 31.1 (May 2009): 128–29.

"Tell My Heart." *Indiana Review* 31.1 (May 2009): 127.

"*Losing the Way,* 1930." *Callaloo • Art / Callaloo* 37.4 (2014): 894.

"*Domino Players,* 1943." *Black Renaissance / Renaissance Noire* 11.1 (Spring 2011): 74.

"The Satisfactions of a Limited View." *Callaloo • Art / Callaloo* 37.4 (2014): 835.

"Topoanalysis." *Missouri Review,* Poem of the Week, November 10, 2014.

"*Victorian Interior, 1945.*" *Phoebe: A Journal of Literature and Art* 35.2 (Fall 2006): 56–57.

"1939." *FIELD* 89 (Fall 2013): 50.

"*The Trapper Returning Home, 1941.*" *Black Renaissance / Renaissance Noire* 11.1 (Spring 2011): 70.

"*Lilies, 1941.*" *Tar River Poetry* 55.1 (2015): 15.

"In a Painted Room." *The Cincinnati Review* 12.2 (Winter 2016): 121.

"Why, Oh Why, the Doily?" *Beloit Poetry Journal* 61.2 (Winter 2010/2011): 24-29. Reprinted in *Crochet Traditions* (Fall 2012): 113-115.

"Newly Discovered Portrait of America's First Black President by Horace H. Pippin (1888–1946)." *Callaloo • Art / Callaloo* 37.4 (2014): 874.

"Erotica." *River Styx* 91/92 (2014): 36.

⊟ ⊟ ⊟

ABOUT THE AUTHOR

Janice N. Harrington's first book of poetry, *Even the Hollow My Body Made Is Gone,* won the A. Poulin, Jr. Poetry Prize and the Kate Tufts Discovery Award. Her second book of poetry is *The Hands of Strangers: Poems from the Nursing Home.* Harrington has also written the children's books *Going North* and *The Chicken-Chasing Queen of Lamar County,* and a children's verse novel, *Catching a Storyfish.* She teaches creative writing at the University of Illinois.

⊞ ⊞ ⊞

BOA EDITIONS, LTD.
AMERICAN POETS
CONTINUUM SERIES

COLOPHON

BOA Editions, Ltd., a not-for-profit publisher of poetry and other literary works, fosters readership and appreciation of contemporary literature. By identifying, cultivating, and publishing both new and established poets and selecting authors of unique literary talent, BOA brings high-quality literature to the public. Support for this effort comes from the sale of its publications, grant funding, and private donations.

▣ ▣ ▣

The publication of this book is made possible, in part,
by the support of the following patrons:

Anonymous
Gwen & Gary Conners
Steven O. Russell & Phyllis Rifkin-Russell

and the kind sponsorship of the following individuals:

Anonymous x 2
Nin Andrews
Nickole Brown & Jessica Jacobs
Bernadette Catalana
Christopher & DeAnna Cebula
Anne C. Coon & Craig J. Zicari
Jere Fletcher
Michael Hall, *in memory of Lorna Hall*
Sandi Henschel, *in loving memory of Anthony Piccione*
Grant Holcomb
Christopher Kennedy & Mi Ditmar
X. J. & Dorothy M. Kennedy
Keetje Kuipers & Sarah Fritsch, *in memory of JoAnn Wood Graham*
Jack & Gail Langerak
Daniel M. Meyers, *in honor of James Shepard Skiff*
Deborah Ronnen & Sherman Levey
Sue S. Stewart, *in memory of Stephen L. Raymond*
Lynda & George Waldrep
Michael Waters & Mihaela Moscaliuc
Michael & Patricia Wilder